Turner's Birds

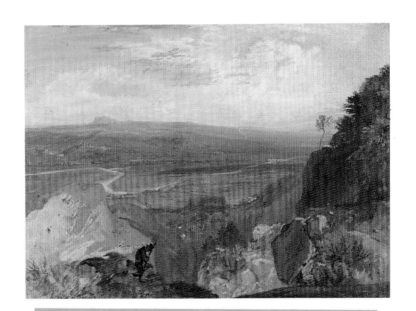

Turner

Published in association with the Leeds Art
Collections Fund. Publication and exhibition
sponsored by

Hepworth & Chadwick
Solicitors · Leeds

's Birds

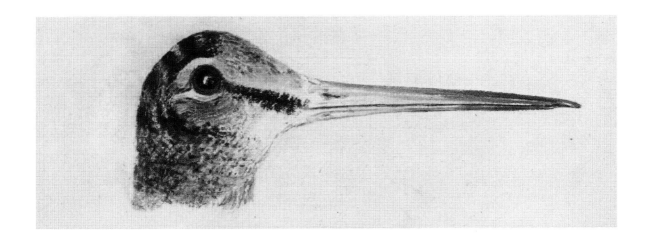

Bird Studies from Farnley Hall

David Hill

Phaidon · Oxford

Published for the exhibition *Turner at Farnley. The Book of Birds* held at the City Art Gallery, Leeds, April–June 1988, and the Clore Gallery, Tate Gallery, London, 10 October–11 December 1988

Phaidon Press Limited, Littlegate House, St Ebbe's Street, Oxford OX1 1SQ

First published in 1988

British Library Cataloguing in Publication Data

Turner, J.M.W. (Joseph Mallord William),
 1755–1851
 Turner's birds: bird studies and
 landscapes from Farnley Hall.
 1. English watercolour paintings. Turner,
 J.M.W. (Joseph Mallord William), 1755–1851.
 Catalogues
 I. Title II. Hill, David, *1953 Apr. 24–*
 759.2

 ISBN 0–7148–2531–X
 ISBN 0–7148–2532–8 Pbk

Typeset by Keyspools Ltd, Golborne, Lancashire

Printed in England by the Roundwood Press, Kineton, Warwickshire

Acknowledgements

We would like to thank the following for their assistance during our research and for facilitating the loan of works to the exhibition: Thomas Agnew and Sons Ltd; Bradford Art Galleries and Museums; Clore Gallery for the Turner Collection, Tate Gallery, London; Mr and Mrs Nicholas Horton-Fawkes; National Portrait Gallery, London; West Park Studios, Leeds.

We are also grateful to the following for allowing us to reproduce their paintings here: Bradford Art Galleries and Museums (p. 16); Mr and Mrs Nicholas Horton-Fawkes (pp. 4, 8, 11, 13, 15, 16, 19, 21, 23, 25); Leeds City Art Galleries (pp. 6, 27, 28, 30, 32, 34, 36, 40, 42, 44, 46, 48, 50, 52, 54, 56, 58, 60, 62); Private Collection, U.K. (p. 17). We would also like to thank the following for kindly supplying photographs of the paintings: Thomas Agnew and Sons Ltd (p. 17); Bradford Art Galleries and Museums (p. 16); National Portrait Gallery (p. 4); West Park Studios, Leeds (pp. 4, 6, 8, 11, 13, 15, 16, 19, 21, 23, 25, 27, 28, 30, 32, 34, 36, 38, 40, 42, 44, 46, 48, 50, 52, 54, 56, 58, 60, 62).

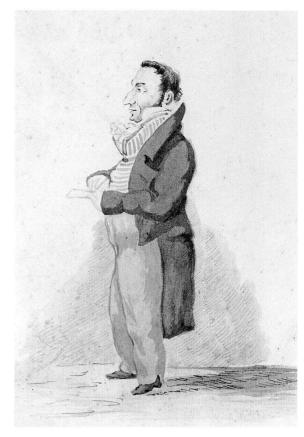

Above: Caricature of J.M.W. Turner. Drawn by Hawksworth Fawkes in about 1820. Mr & Mrs Nicholas Horton-Fawkes.

Half-title: Wharfedale from Caley Park, 1818. Bodycolour on grey paper, 32·7 × 44 cm. Mr & Mrs Nicholas Horton-Fawkes.

Front cover: The Peacock. Leeds City Art Galleries.
Back cover: Valley of the Washburn. Private Collection.

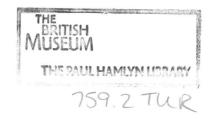

Contents

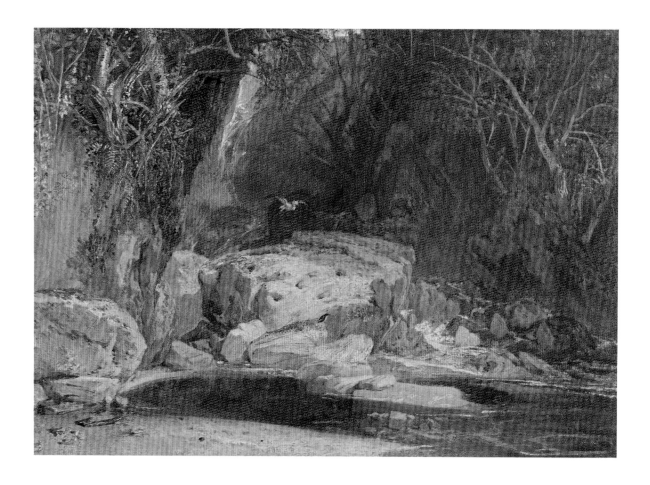

A Lonely Dell, Wharfedale, c.1809. Watercolour, 30·9 × 40 cm. Leeds City Art Galleries. The exact location of this watercolour has never been identified, although its oldest-known title, under which it was sold at John Knowles' sale at Christies in 1880, identifies the locality as Wharfedale.

Foreword

The campaign to save Turner's *Book of Birds* from leaving the country was happily resolved when the album of twenty watercolours sold from Farnley Hall was bought by Leeds City Art Gallery in 1985, after a successful public appeal with the greatest contribution coming from the National Heritage Memorial Fund. The drawings have since been cleaned and conserved and can now be enjoyed by the general public.

We are delighted that as one of Leeds City Art Gallery's centenary celebrations a special exhibition of Turner's bird watercolours together with views of Farnley Hall and Wharfedale has been sponsored by Leeds solicitors Hepworth & Chadwick, and that in the autumn the exhibition will be seen in the new Clore Gallery at the Tate Gallery in London.

Our thanks are due to David Hill for his essay on Turner at Farnley Hall and to Michael Densley for supplying the commentaries on the birds themselves. As always, we are especially grateful to private owners for the loan of watercolours to the exhibition: Mr and Mrs Nicholas Horton-Fawkes have been most generous with loans from Farnley Hall, and we would also like to thank the Trustees of the Tate Gallery, the Director of Bradford Art Gallery and Museums and William Agnew of Messrs. Thomas Agnew and Son for his very helpful co-operation. Ron Collier of West Park Studios, Leeds was responsible for most of the excellent photographs used in this book.

Christopher Gilbert, Hon. Secretary, Leeds Art Collections Fund

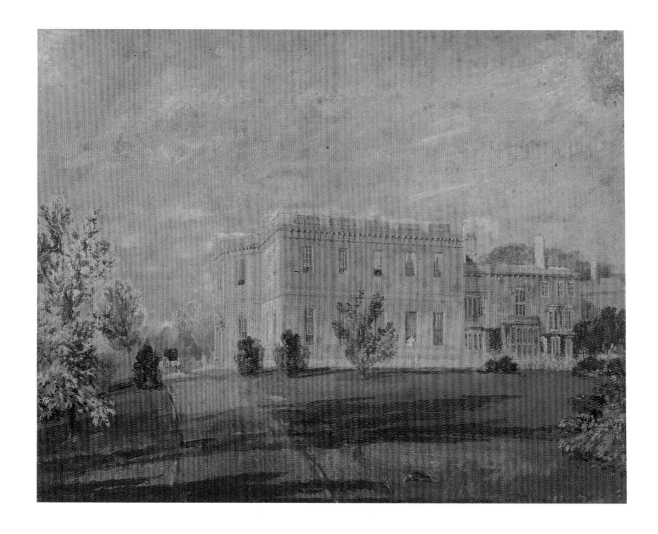

1. *Farnley Hall, the 'New House' from the East*, c.1816. Bodycolour and black chalk on buff paper 31·1 × 39·4 cm. Mr & Mrs Nicholas Horton-Fawkes. Turner recorded that this drawing was commissioned for the price of 10 guineas. The three ground floor windows to the left are those of the Dining Room (Fig. 9). Fawkes and a dog step out of a carriage at the left, and a woman looks out at Turner from the fourth window to the right.

Turner at Farnley Hall

Anyone seeking to discover the real Turner could hardly start at a worse place than his exhibited oil paintings. They only show the face that Turner wanted to present to his public. So we see a great genius of the Royal Academy, the Professor of Perspective, and all the convention, allusion, and artifice appropriate to the Greatest Landscape Painter of His Time. The private face is harder to discern and of Farnley Hall nothing is seen. Yet this house and its owner, Walter Fawkes, occupied a vital place in Turner's life, and are central to any understanding of the man or his art.

For twenty years or more Fawkes was one of the artist's few close friends, perhaps the closest, and he was certainly Turner's most important patron. He entertained the artist at Farnley most years between 1808 and 1824, welcoming him virtually as a member of the family and keeping a room permanently reserved and equipped for his use. At Farnley Turner could relax among friends who cared for him as well as for his work. We hear that 'he shot and fished and was as playful as a child'; that he drove gigs rather recklessly and was consequently known as 'Overturner';[1] that he was observed to hang out his watercolours, 'papers tinted with pink and blue and yellow' on washing lines in his room to dry;[2] that he allowed the children to watch him paint[3] and that he even gave advice on watercolour painting, albeit of a rather enigmatic kind: 'Put it in a jug of water'.[4]

Turner filled several sketchbooks with records of Farnley Hall and the surrounding landscape, and he used the house as a base from which to make numerous sketching tours in the north of England, including his most celebrated tour of 1816 to gather illustrations for Thomas Dunham Whitaker's *General History of the County of York*. Fawkes took a keen interest not only in Turner's Yorkshire tours, but also in each of his first three tours on the Continent, to Paris and the Alps in 1802, to Waterloo, Holland and the Rhine in 1817 and to Italy in 1819–20. He was virtually the only buyer of pictures resulting from these tours, including a whole sketchbook of watercolours from the Rhine.

During the later years of Turner's association with the house, he shared Fawkes' interests in poetry, history and ornithology, and made illustrations for various albums for the library, including a five-volume *Ornithological Collection* for which he made the twenty drawings of birds now at Leeds City Art Gallery. He also made a series of informal bodycolour 'sketches' of the house and grounds, which have a directness of handling, simplicity of vision and quality of intimacy which is quite unique in his work. In their apparent artlessness we can sense that here something of the real Turner is revealed.

Farnley Hall stands above a rolling sweep of parkland overlooking the Wharfe valley near the Yorkshire market town of Otley. The Fawkes family has been associated with the estate since at least the thirteenth century and the house which Turner knew survives today, the private home of descendants of Turner's patron, who have over recent years restored the building and its decorations to marvellous condition. The house as it was painted by Turner (Fig. 1) comprised of a late sixteenth-century wing on to which Walter Fawkes' father had built a large modern house by John Carr of York, after inheriting the estate in 1786. From the south terrace the new house commands a panoramic view of the Wharfe valley from Pool Bridge to the east, over Caley Crags and Otley Chevin opposite, to Otley Bridge and town to the west. To the north east of the house pleasure grounds, including Lake Tiny, extend to the Washburn valley, a favourite haunt of Turner's, and to the north west the moors stretch to Beamsley Beacon and Kex Gill, the scene of numerous shooting parties in which Turner participated. Over a period of sixteen years Turner recorded virtually every aspect of the area in some of his most meticulous and caring pencil sketches and watercolours.

Walter Fawkes, born in 1769, was six years Turner's senior. In 1792, aged twenty-three, he inherited the newly completed house and estate from his father. Two years later he married and began a family of four sons and seven daughters. His interest in collecting pictures was immediately evident. He bought four oils by William Hodges in 1794, he paid 300 guineas for a Ruisdael in 1796, and in 1798 bought pictures from the Orleans collection: a picture by the marine artist William Anderson and Swiss views by John Warwick Smith.

Fawkes and Turner seem to have met in connection with Turner's first continental tour, to the Alps in 1802, the year he was elected full Royal Academician. Fawkes had been to Switzerland himself, and it has been suggested that it was he who persuaded Turner to go in the first place and may even have suggested many of the viewpoints. It is clear that Fawkes took a keen interest in the sketchbooks Turner brought back with him. Over the next few years he bought more than twenty finished watercolours and two oil paintings, based on drawings in them. His first purchase was a watercolour exhibited at the Academy in 1803, and he followed this up almost immediately with an order for three more. In 1805 he subscribed to Turner's print of *The Shipwreck*, and, probably in 1808, bought a pair of paintings, *Calm, Three Deckers at Anchor*, and *Portrait of the Victory, in Three Positions, passing the Needles, Isle of Wight*. These paintings are seen hanging either side of the fireplace in the watercolour of the *Drawing Room* (Fig. 2).[5]

In 1806 Fawkes stood for Parliament against the long-time holders of the seat for the County of York, and Turner's earlier Yorkshire patrons the Lascelles family. Fawkes was elected amid tumultuous scenes after spending up to £1000 per day on his campaign.[6] He supported the campaign for the Abolition of Slavery and spoke in favour of Parliamentary reform and Catholic emancipation, recalling the spirit if not the directness of his distant ancestor, Guy Fawkes.[7] It would be imprudent to read too much of Turner's own politics into his relationship with Fawkes, but during this period the patronage warmed into friendship and in 1808 Turner was invited to stay at Farnley for the first time.

Turner travelled from Tabley Hall in Cheshire by way of the Craven Dales where he sketched Weathercote Cave, Ingleborough, Malham Cove and Gordale,[8] and during his stay at Farnley he made his first sketches of the house and the Wharfe valley from the quarries at Caley, and of the Washburn valley at Leathley. He also made an excursion up the Wharfe to Addingham where he sketched the mill,

2. Farnley Hall, the Drawing Room, 1818. Bodycolour on buff paper, 31·5 × 41·2 cm. Mr & Mrs Nicholas Horton-Fawkes. Above the fireplace can be seen Turner's painting of *Dort, or Dordrecht Packet Boat Becalmed*. The picture was bought as a twenty-first birthday present for Hawksworth Fawkes, and must only have been recently installed when Turner painted this picture. Two other paintings by Turner can also be seen. To the left, *Calm, Three Deckers at Anchor*, and, to the right, *Portrait of the Victory, in Three Positions, passing the Needles, Isle of Wight*.

and to Bolton Abbey, the principal object of the tour, where he made a number of sketches of the priory, the Strid and Barden Tower.[9] The sketches from this summer formed the basis for half of the series of twenty watercolours – ten Yorkshire subjects and ten Alpine – which Fawkes commissioned at this time.[10]

His commitment to Turner's work strengthened still further in 1809, when he bought two oil paintings, *Shoeburyness Fishermen hailing a Whitstable Hoy*, and a view of *London* from Greenwich. In 1810 he bought another large oil painting, *Lake of Geneva, from Montreux, Chillon & c.* Some arithmetic in one of Turner's notebooks of this time shows that Fawkes's debt to the artist stood at no less than £1000.[11] Over the next three or four years he bought less from Turner, but during this period Turner became an annual visitor to the house, usually in the autumn for the shooting. In 1810 he sketched the storm which reappeared in *Snow Storm: Hannibal and his Army crossing the Alps*, exhibited in 1812,[12] but the main purpose of his visits to Farnley was to give himself a holiday. In November 1812 he felt out of sorts at an Academy Council meeting and proposed to go to Farnley where the 'air, moderate exercise and changing his situation would do most for him',[13] and not until 1814 do we find him sketching much again.[14]

Fawkes had by this time begun his conversion of the old part of the house into a museum to house the relics of his ancestor General Fairfax, and other relics of the Civil War period which had descended to him, including Oliver Cromwell's hat. Fawkes owned a number of sixteenth- and seventeenth-century houses in the area and began to remove architectural features: bay windows from Lindley Hall; the porch from Newhall; a gateway from Menston; panelling from Hawksworth; fireplaces, stained glass and lancets from various sites (Fig. 3). From 1814 Turner followed these removals and rebuildings closely in his watercolours. Fawkes was an enthusiastic historian and published *The Chronology of the History of Modern Europe* in 1810, and Turner shared in this interest by providing frontispieces for a history of Parliament from the time of Charles I through the Civil War to the Glorious Revolution of 1688. He also made drawings of the Fairfax and Cromwellian relics for an album entitled *Fairfaxiana*. Some of the drawings are the result of hours of painstaking and tedious work. The *Frontispiece* includes various documents and pedigrees with their texts fully transcribed in hundreds of lines of microscopic facsimile handwriting.[15] This interest continued for a number of years. In October 1823 John Cam Hobhouse called at Farnley and with a distinct note of incredulity observed: 'the most celebrated landscape painter of our time – I mean Turner, who was employed in making designs for a museum intended to contain relics of our civil wars and to be called Fairfaxiana' (Fig. 4).[16] Turner was most certainly paid for his work, but it could hardly be called employment. He did these drawings because he found them, the subject, and his host, interesting. He enjoyed it. So, evidently, did Hobhouse: 'A more agreeable host than Mr Fawkes I have never seen, and his political recollections were very amusing. He repeated one day a squib which he wrote during his Yorkshire contest:

> What has Lascelles to hope
> From this cry of "No Pope!"
> And his zeal for the Faith's great Defender?
> Since all of us know
> That his brother the Beau
> Has long been the only Pretender.'[17]

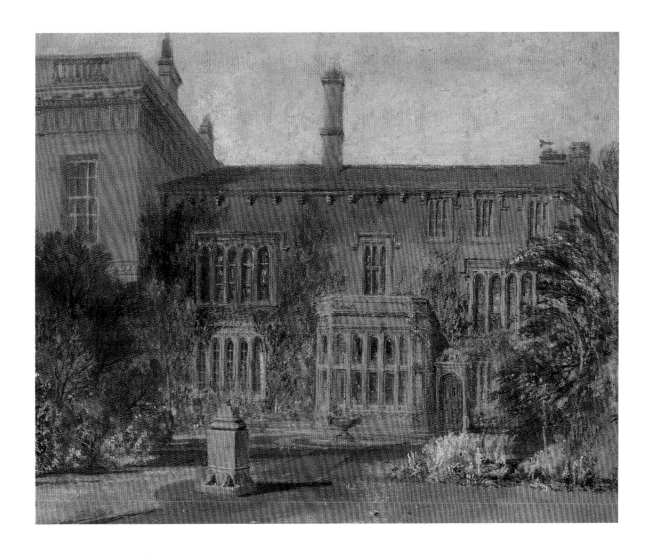

3. Farnley Hall, the Old house and flower garden, c.1818. Bodycolour and black chalk on buff paper, 31·7 × 41·3 cm. Mr & Mrs Nicholas Horton-Fawkes. John Carr's house, to the left, was built on to a late sixteenth-century house which, from 1814, Fawkes turned into a museum of the Civil War period. He remodelled the house, bringing architectural features from a number of houses in his possession. The bay windows seen here came from Lindley Hall in 1814.

In 1816 Turner secured the opportunity to make a full record of the northern landscape in one hundred and twenty watercolours when he was commissioned by Longmans to illustrate Whitaker's *General History of the County of York*. He used Farnley as a base for his sketching tour, and for the first ten days travelled in the company of the Fawkes family. His 550-mile tour, one of the most important in his career, is fully explored elsewhere,[18] but throughout his tribulations in the rain and the mire Turner was spurred on by the prospect of a shooting party on the Farnley moors to be held on the Glorious 12th. Turner sketched the party and the gentlemen on the moors, and made finished watercolours of both, one of which (Fig. 5) shows Walter Fawkes, clearly identified by the lettering on the tarpaulin next to him, in the centre holding up a blackcock shot on the moors.

This watercolour shows Fawkes holding a bird very similar to the *Dead Blackcock* now at the British Museum.[19] It is one of a number of drawings, including pheasants at the Whitworth Art Gallery, Manchester,[20] and Ashmolean Museum, Oxford,[21] and a grouse at the Indianapolis Museum of Art[22] which all came from Farnley Hall and which probably belonged to the *Ornithological Collection* from which the twenty drawings now at Leeds City Art Gallery were taken. There are, in addition, a number of birds in the Turner Bequest which were probably drawn at Farnley,[23] and which may have been associated with the albums, but which Turner retained for his own use. The original albums survive in the Farnley library to this day intact except for the Turner drawings. The five large, morocco-bound volumes each contained about one hundred sheets of alternately interleaved brown and white paper, the latter with a red wash-line border. On the versos of each brown page were pasted the illustrations from an 1805 edition of Thomas Bewick's *History of British Birds*,[24] and in the back of each volume was pasted appropriate parts of the contents list from Bewick to serve as an index. A number of Bewick's birds were omitted, the eagles for example, but two hundred and twenty one were incorporated in roughly the same order as in Bewick. The albums use the same system of classification, beginning with the birds of prey, followed by other land birds, and ending with the water birds.

The object of the *Ornithological Collection* was to collect specimens of the bird's feathers from the head, neck, wings, breast, tail and back, occasionally incorporating unusual features such as the beak of a spoonbill, or the leg of a Long-Legged Plover. The collection is complete except for the fifth volume which was to contain the larger water birds, many species of which, the Swan Goose and the Canada Goose for example, remained uncollected. Although, all the birds drawn by Turner were local, by no means all the specimens in the albums would have been found in the vicinity, or even in Yorkshire, and the collection must have involved a trading of examples with other collectors. Two keen ornithologists known to have been visitors to Farnley Hall are George Walker who had an aviary at Killingbeck Hall in Leeds, and who also painted a dead grouse onto a panel in the old wing at Farnley, and Charles Waterton of Walton Hall near Wakefield, a noted naturalist, explorer, taxidermist, collector and Cayman-wrestler,[25] who also had an aviary, and whose portrait was painted by Hawksworth Fawkes, the son and heir of Turner's patron.[26] On the rectos of the brown leaves were pasted watercolours, some by the gentleman semi-professional illustrator Samuel Howitt,[27] and others by family and friends, including Frances Fawkes, Miss I. Middleton, Lady Armytage and Edward Swinburne. Enthusiasts and collectors cannot have been hard to find. In 1818 *Blackwoods Magazine* could report in an article entitled: 'Proofs of the Increasing Taste for Natural History', that the subject had 'become a general study. The man of

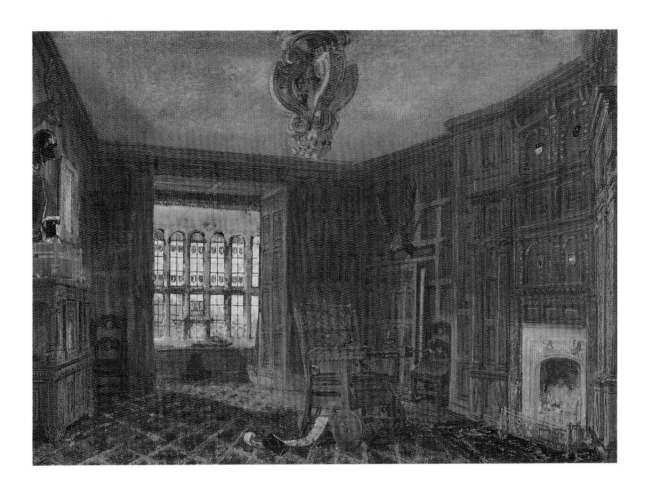

4. Farnley Hall, the Oak Room, with General Fairfax's Chair, c.1818. Bodycolour on grey paper, 29·2 × 40·6 cm. Mr & Mrs Nicholas Horton-Fawkes. Turner sketched the Oak Room in 1814 and in the same sketchbook there are measurements and details of fireplaces and panelling, including several suggestions for rearrangements of the panelling over the fireplace. All this suggests that Turner had a hand in the creation, and even the design of Fawkes museum of the Civil War period. General Fairfax's extraordinary chair features prominently.

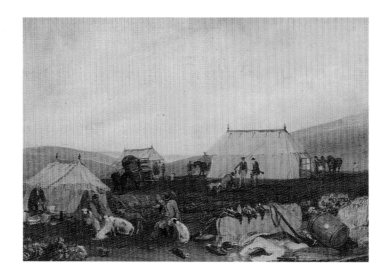

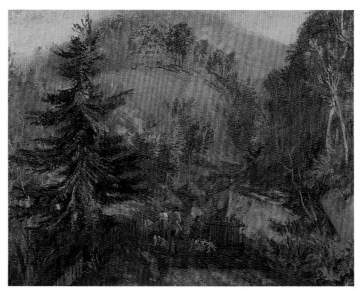

5. *Above: Shooting Party on The Moors,* 12 August, 1816. Watercolour with scratching-out, 28 × 39·7 cm. Inscr: (lower left) 'JMW Turner'; and, to the left of the central figure, 'W FAWKES FARN[LEY]': 'Ale' in the barrel to the right. Mr & Mrs Nicholas Horton-Fawkes. Since this watercolour is based on a sketch in the 'Large Farnley' sketchbook, which can now be dated to 1816, we can be sure that this is the same shooting party which Turner rushed through his Yorkshire tour of that year to be back at Farnley for.

6. *Below: Gates at the West Entrance to Caley Park, Otley Chevin,* 1818. Bodycolour on grey paper, 34 × 43·4 cm. Bradford Art Galleries and Museums. Caley Park lies on the south side of the Wharfe valley opposite Farnley Hall, and was stocked as a game park by the Fawkes family. The watercolour was based on a sketch in the 'Farnley' sketchbook of 1818.

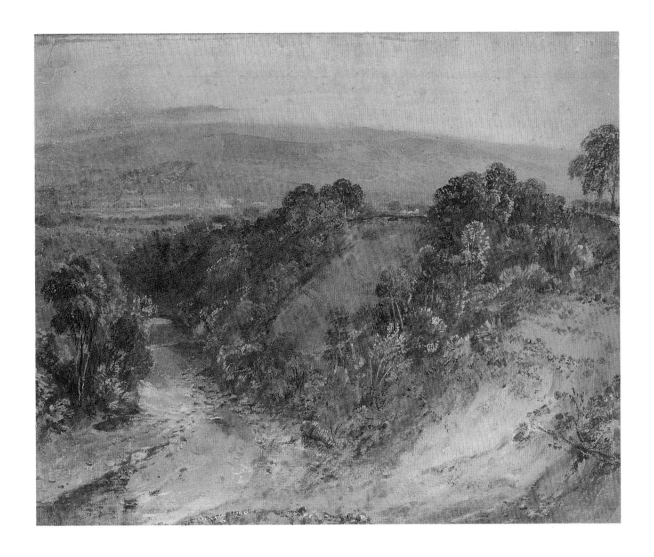

7. *Valley of the Washburn*, c. 1818 Watercolour and bodycolour on buff paper, 33·1 × 40·9 cm. Private Collection. This watercolour is based on a sketch in the 'Hastings' sketchbook which was used at Farnley in 1816. It shows the view south from the Washburn valley near Leathley, towards Caley Park across Wharfedale in the distance. Lake Tiny is over the bluff to the right.

business, as well as the philosopher, takes an interest even in the details of this delightful branch of knowledge.'[28] On Fawkes' death in 1825 the composer of some *Elegiac Stanzas* the Revd. Henry Foster Mills, made specific references to his interest in the natural sciences:

> Nor less on Science wings I've seen thee soar,
> Search nature's laws by some *FIRST CAUSE* design'd;
> The various earths and mineral world explore,
> And give fresh vigour to thy copious mind.[29]

According to another commentator: 'a cabinet of natural (and artificial) "curiosities" had come to be regarded as one of the essential furnishings of every member of the leisured classes with claims to be considered cultivated'. Only the Fawkes family, however, had the greatest painter in the country to illustrate their 'cabinet of natural curiosities'.[30]

Turner recalled his involvement with the *Ornithological Collection* in a letter to Hawksworth Fawkes written only ten months before the artist's death. He was acknowledging the customary Christmas gift of game from Farnley, in this case a brace of Longtails and a brace of Hares. 'The Birds,' he remembered, 'were pasted or fixed in Major Fawkes Book of Ornithology rather of a large size to illustrate his wishes. A Cuckoo was my first achievement in killing on Farnley Moor in earnest request of Major Fawkes to be painted for the book.'[31] Major Fawkes can be identified as Major Richard Fawkes, Hawksworth's younger brother, born in 1809 and thus a boy of seven at the time Turner became involved with the project. It is hard to imagine a boy of this age compiling such a beautiful and methodical album himself, but nevertheless the clear inference of Turner's recollection is that it was at least compiled for his amusement and education. Turner's own interest, however, was sufficiently aroused for him to have contributed more drawings to the book than anyone else.

The spirit in which the specimens were collected was far from scientific if another passage of marvellously bad poetry from the Revd. Mills' *Elegiac Stanzas* can be taken as a guide:

> ... free to play,
> We little sportsmen ranged the fields along,
> Mark'd the poor linnet on his willow spray,
> And stopp'd with thund'ring tube his dulcet song.

However, the gung-ho spirit will not have been quite so strong after Walter Fawkes' brother, Richard, was killed in a shooting accident at Farnley in 1816. In fact something of the modern conservationist spirit was present in the circle of ornithologists who gathered at Farnley. Charles Waterton created a bird sanctuary at Walton, threatening to strangle gamekeepers who molested the owls, and building nesting boxes on top of his gateway. However, of the twenty birds now at Leeds, most of those that are shown whole are dead. Of the six whole birds, the two that are drawn from life, the *Robin* and the *Goldfinch*, are conspicuously weaker in execution and observation. Turner's approval of a catalogue of all the Farnley Turners, made in 1850, in which they are expressly listed,[32] leaves no doubt that they are authentic, and their quality must be the product of working from fleetingly observed specimens, perhaps lured to a bird-table by a window. For observation and recording, dead specimens were necessary, and for the

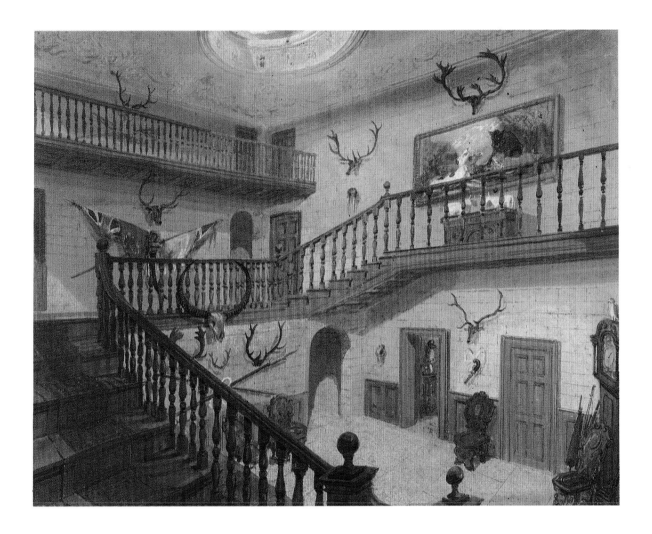

8. *Farnley Hall, Old Staircase*, Farnley c.1818. Bodycolour on buff paper, 31·8 × 41·1 cm. Mr & Mr Nicholas Horton-Fawkes. The oak staircase in the sixteenth-century wing, hung with part of Fawkes' collection of Parliamentarian banners. Below can be seen a couple of pikes, and on the landing top right hangs the *Boar at Bay* by Frans Snyders, which Fawkes bought from the Orleans collection in about 1798.

most part Turner avoided having to confront their being dead by concentrating on the heads only. In the others, however, the *Dead Kingfisher*, *Dead Wood Pigeon*, *Dead Grouse, Hanging*, and *Dead Jay*, the birds are pathetic corpses. No attempt has been made to give any illusion of life. Far from it: the heads are bent at odd angles, the pigeon dumped on its back, the grouse hung from a string by one leg, a dead wing flopping uselessly. Turner deliberately makes us confront their lifelessness as well as their beauty, and by drawing attention to the only condition under which the pleasure of close examination can be obtained, remainds us of their recent fate.

Although Turner's bird drawings have a scientific context, they are not like the drawings of a scientific ornithologist. It is worth noting that the *Ornithological Collection* is not constructed on strict scientific principles. It is significant that Thomas Bewick, the starting point of the collection, was much more of an artist than a scientist,[33] and the pre-eminence he earned in the ornithological fraternity until his book was superseded was not earned by his scientific method. It is of further significance then, that there is neither text nor notes in the Albums, not even the text from Bewick, which was discarded, although further bound copies of the book were kept in the library. Nor is Turner's observation at all scientific. It would be hard to read the exact nature of the plumage from the paint and chalk which passes for a record of *The Barn Owl*, or to deduce the structure of the neck feathers from the passages of blue and grey and black in the head of the *Peacock*. There is no consideration in the album of the actual structure of any of the feathers, or of the skeletal structure of the birds, their manners, life cycle or habitat. There is, however, a sense of marvelling at the beauty of these birds, a sense of privilege at closing so intimately with these otherwise barely known or considered creatures. It is the delight of close scrutiny, a care and love for these things, which is the real subject of Turner's paintwork. In this and in many other things he is the first artist to make visible what we may feel.

In contrast to the dead birds, Turner invests the paintings of the heads with animation and even some sense of personality. The gaze of the Owl, for example, is downturned as if absorbed in contemplation, a sense reinforced by the tilt of the head. The Woodpecker's bright eye and slightly parted beak suggest a perky brightness. The Heron is caught at the moment of seizing a fish, its crest feathers instinct with exclamation. The Turkey looks distinctly foolish, while the Peacock is knowing and proud. There is an element of empathy in these drawings, and Turner's identification with birds is a recurrent theme. The children at Twickenham, where he built a house in 1812 called him 'Old Blackbirdy' on account of the protection he gave to the birds in his garden. He grew his left-hand thumbnail long 'like an eagle's-claw', to scratch at the paper on which he was painting. He speaks in his letters of being 'on the wing'. He often made play of the similarity of his name Mallord with Mallard. On his Yorkshire tour of 1816 he wrote that the weather was miserably wet and that he would be 'web-footed like a drake, except the curled feather', and in another letter he substituted a drawing of a duck on the wing for the word Mallord.[34] In many pictures ducks on the wing serve almost as a signature, and most of Turner's works include a bird or birds somewhere. They are often portrayed as the sole inhabitants of landscapes, and in the watercolours of *A Lonely Dell, Wharfedale* (Page 6), whose proper subject has never been identified, and *Valley of the Washburn* (Fig. 7), he places birds which he had studied for the *Ornithological Collection*, herons and kingfishers, in their environment. It was as if they were the natural and rightful inhabitants of the landscape he came to as a visitor and a fisherman. In a watercolour

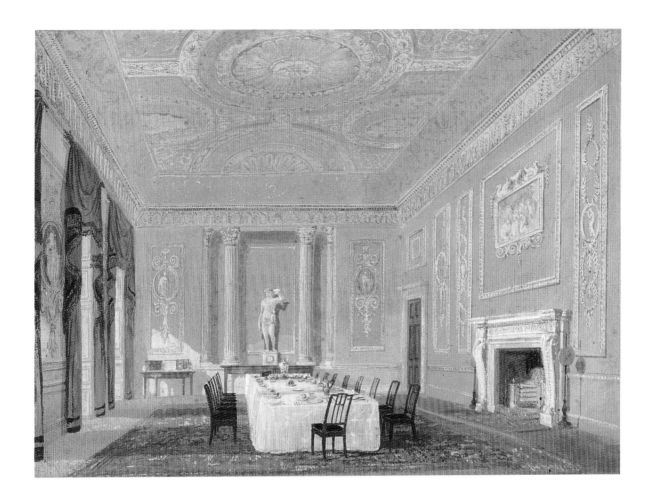

9. Farnley Hall, the Dining Room, c.1818. Bodycolour on buff paper, 31·4 × 42·8 cm. Mr & Mrs Nicholas Horton-Fawkes. Perhaps the most elaborate of Carr's rooms in the new wing. The plasterwork is reputed to be by Joseph Rose, who also worked at Harewood. The fireplace is by John Fisher of York, the painted medallions by a Swiss painter, Theodore de Bruyn, and the chairs by Gillows of Lancaster.

of Cauldron Snout, which he visited in 1816, there is a portrayal of man as a predatory intruder in a landscape rightly occupied by birds alone. A figure with a gun looms through the distant mist to bring destruction to a family of grouse sunning themselves happily in the foreground.

Between 1816 and 1819 Turner made a complete study of the environment at Farnley. A series of nearly forty watercolours includes views from the Chevin and in Caley Park (Fig. 6 and Page 1), of the sporting amusements, interiors and exteriors of the house (Figs. 8, 9 and 10), including another aspect of the Fawkes' interest in natural science, *The Conservatory* (Fig. 11), and views in the park around Lake Tiny and in the Washburn valley. These watercolours are unique in Turner's *œuvre* for their apparent spontaneity. The fact is that they are mostly based on pencil drawing in sketchbooks and are studio works. However, they are made in such a manner as to look like they were painted out of doors direct from the motif. The use of coloured papers had been associated with sketching from the motif from the seventeenth century, artists preferring it in the bright light of the Campagna. An opaque gouache-like paint was used to cover the coloured paper often being worked wet into wet, so exploiting chance drying marks and accident for effect. Its very opacity which also allowed for the covering of mistakes, is in complete contrast to the brilliant, decisive, sharp, pre-planned watercolours on white paper or Bristol board which Turner normally presented to the public. These Farnley drawings have an *ad hoc* appearance, as if the artist were confronting his motif and responding to it directly.

Fawkes took a particularly close interest in the way Turner worked with his motif. The following year he bought a whole sketchbook of coloured drawings which Turner had made on a tour of the Rhine. He is an early example of a patron being interested as much in the artist and his working methods as in the finished works. When he presented these 'sketches' to the public at his London house in 1819, a number of commentators were ready to acknowledge their importance, and one in particular, the critic of the *Repository of Arts*, recognized what they would reveal to those with a knowledge of artists' practices: 'They appeared to us (at least many of them) to be done in distemper, and will perhaps by artists be preferred to the finished drawings in the adjoining apartment. As they are not classed in the catalogue, it is impossible for us to refer to them in detail; it will be sufficient to say that they are the best examples we have ever seen of the unrivalled powers of this artist in landscape views.'[35]

During the exhibition of his collection in 1819 Fawkes collected a number of the reviews and published them together with a catalogue. He included a most remarkable public tribute:

> *My Dear Sir,*
> *The unbought and spontaneous expression of the public opinion respecting my Collection of Water Colour*
> *Drawings, decidedly points out to whom this little Catalogue should be inscribed.*
> *To you, therefore, I dedicate it; first as an act of duty; and, secondly, as an Offering of Friendship;*
> *for, be assured, I never can look at it without intensely feeling the delight I have experienced during*
> *the greater part of my life, from the exercise of your talent and the pleasure of your society.*
> *That you may year after year reap an accession of fame and fortune, is the anxious wish of*
> *Your sincere Friend,*
> *W. FAWKES*

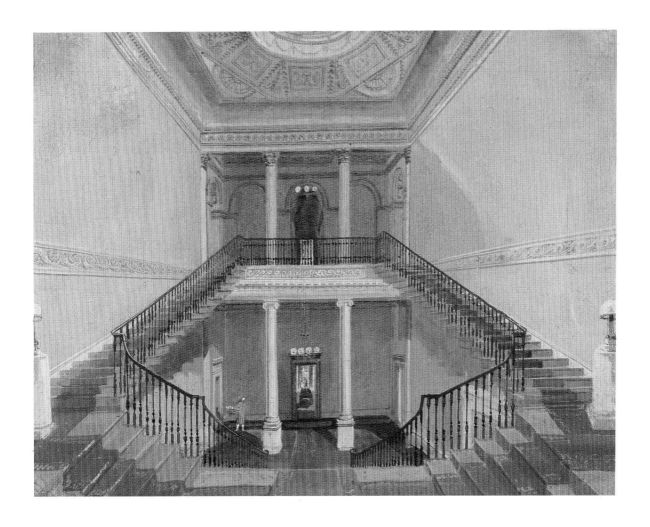

10. *Farnley Hall, the 'Modern Staircase'*, c.1818. Bodycolour on buff paper, 31·5 × 41·2 cm. Mr & Mrs Nicholas Horton-Fawkes. Showing the staircase in John Carr's wing. To the left a servant enters the Dining Room. To the right is the door into the Drawing Room, and, ahead, the door into the Saloon.

Fawkes died on 25 October 1825. In a letter written the following January Turner reflected 'Alas! my good Auld lang sine is gone . . . and I must follow; indeed I feel as you say, near a million times the brink of eternity'.[36] He could not be persuaded to visit Farnley again, although he remained in close touch with Fawkes' son Hawksworth until the end of his life. A number of letters written in the last years of his life express his feelings about Farnley and what was one of the most affirmative periods in his life. On 28 December 1844 he wrote to thank Hawksworth for a Yorkshire pie 'equal good to the olden time of Hannah's culinary exploits'.[37] 'Now for myself,' he wrote, 'the rigours of winter begin to tell upon me, rough and cold and more acted upon by changes of weather than when we used to trot about at Farnley, but it must be borne with all the thanks due for such a lengthened period.' On 27 December 1847 he wrote to give some advice about what Hawksworth might see in Wales, hoping 'you may feel – just what I felt in the days of my youth'.[38] On 24 December 1849 he remembered 'Farnley like former times', remarked that 'Old Time has made sad work of me since I saw you in Town', and offered his 'thankfull remembrance' to all at Farnley.[39] In the last letter to Hawksworth of 31 January 1851 he remembered the book of birds and his first achievement in shooting on the moors. In the same letter is a reference to nineteen drawings, which may refer to the bird drawings since his thoughts turn to the book of birds immediately afterwards.[40]

In May of 1851 Ruskin and his wife Effie visited Farnley, and there may then have been some discussion as to what should be done with the bird drawings. On 8 February 1852 Ruskin wrote to Hawksworth from Venice regarding Turner's recent death: 'it has cast more shadow than I thought over these lagoons which he painted so often – what must it over your secret walks and glens'. Later in the same letter he asks: 'Have you done anything to the drawings of birds yet? I am terrified lest any harm happens to them in framing. Pray tell me they are safe . . .'. Ruskin had advised that the abrasion of the feathers in the album would damage Turner's drawings, so they were taken out and placed in a book. Edith Mary Fawkes remembered that later they were window mounted with great care.[41] At this later stage the mounts were bound into an album,[42] in which form they were sold from Farnley in 1984[43] to finance the restoration of the house. After a public appeal the album was bought by Leeds City Art Gallery in January 1985.

Almost exactly one hundred years before that sale, Ruskin was at Farnley again. On Sunday 14 December 1884 Edith Mary Fawkes recorded that: 'he looked at the book of birds, which he had alluded to in the letter of 1852. They seemed to delight him, especially the peacock's head, which he said was a marvel of colour and force, and the kingfisher, which he examined for a long time with a microscope, and he said he could not find words to describe its exquisite beauty. I asked if Turner had painted many birds, and he answered, "Nowhere but at Farnley. He could only do them joyfully there!" '[44]

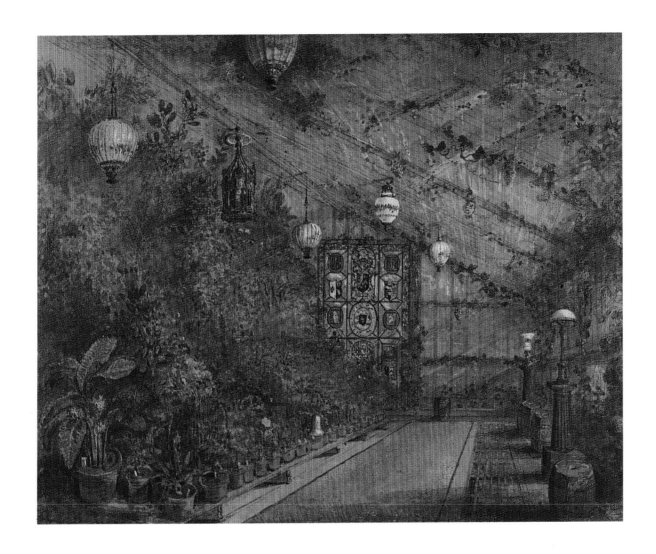

11. Farnley Hall, the Conservatory or 'Root House', c.1818. Bodycolour and watercolour with pen and black ink over black chalk on buff paper, 33·6 × 42 cm. Mr & Mrs Nicholas Horton-Fawkes. This drawing illustrates another aspect in the Fawkes' interest in nature. The stained glass at the far end of the Conservatory reappears in the *Drawing Room* (Fig. 2), and it seems possible that Turner was proposing a new use for it in this watercolour. It is not known whether the Conservatory was ever actually built. The stained glass is now in Farnley church.

Many of the anecdotal sources for Turner at Farnley come from W. Thornbury, *Life of J.M.W. Turner R A* (London 1877). The most recent books to contain material on Farnley are D. Hill, *In Turner's Footsteps* (London 1984), especially p.17ff., and D. Hill *et al.*, *Turner in Yorkshire*, catalogue of the exhibition held at York City Art Gallery, 1980. The standard work on Turner remains A.J. Finberg, *Life of J.M.W. Turner* (Oxford 1961), but A. Wilton, *Turner in his Time* (London 1987), contains material on Farnley. Although it now stands in need of revision, particularly in the light of Turner's sketches and drawings, the one previous book on Turner at Farnley remains A.J. Finberg, *Turner Watercolours at Farnley Hall* (Oxford 1912). An interesting account of the Farnley Hall collection is given in *The Athenaeum*, 1879, p.406ff., 439ff., 470ff., 501ff., 600ff., 636ff. For the natural history context for the bird drawings, David Elliston Allen, *The Naturalist in Britain: A Social History* (London 1976), will provide a fascinating and useful introduction.

Abbreviations

Allen, 1976:	D.E. Allen, *The Naturalist in Britain, A Social History* (London 1976)
Finberg, 1912:	A.J. Finberg, *Turner Watercolours at Farnley Hall* (London 1912)
Finberg, 1961:	A.J. Finberg, *Life of J.M.W. Turner* (Oxford 1961)
Gage, 1980:	J. Gage (ed.), *Collected Correspondence of J.M.W. Turner* (Oxford 1980)
Hill, 1980:	D. Hill *et al.*, *Turner in Yorkshire*, catalogue of exhibition at York City Art Gallery, 1980
Hill, 1984:	D. Hill, *In Turner's Footsteps* (London 1984)
Thornbury, 1877:	W. Thornbury, *Life of J.M.W. Turner, R.A*, 1862, 2nd edn (London 1877)
TB:	Turner Bequest, Clore Gallery for the Turner Collection, Tate Gallery
W:	A. Wilton, *The Life and Work of J.M.W. Turner* (London 1979)

1. Thornbury, 1877, p.237.
2. Quoted J. Gage, *Turner and Watercolour*, exhibition catalogue 1974, p.10.
3. For Hawksworth Fawkes' account of the painting of *The First Rate Taking in Stores*, see Hill, 1984, p.19.
4. *Magazine of Art*, July 1887, p.297.
5. Butlin and Joll, *The Paintings of J.M.W. Turner* (London 1977) 95 and 59. Butlin and Joll note (p.60) that the pictures are of a similar size, but do not consider the possibility that they were bought as a pair. The titles given here are those under which the pictures were exhibited by Fawkes at the Northern Society in Leeds, in 1823.
6. J.A. Clapham, 'Farnley Hall', in William Andrews (ed.), *Bygone Yorkshire*, 1892, p.257.
7. H. Speight, *Upper Wharfedale*, 1900, p.100.
8. TB, CIII (Malham), LI P (Ingleborough), W.547 (Ingleborough, *see* Hill, 1984, p.96), W.541 (Weathercote). The watercolour of Gordale listed by Turner, TB CII, inside cover and f.4, is untraced.
9. Hill, 1980, p.28ff.
10. TB CII Inside cover and f.4.
11. TB CXXII (4).
12. Hill, 1984, p.18.
13. K. Garlick and A. Mackintyre (eds *et al.*), *The Diary of Joseph Farington*, 1978 *et seq.*, 4 November 1812.
14. TB CXXXIII.
15. Frontispiece at the Ashmolean Museum. Exh. York 1980 No.75.
16. John Cam Hobhouse, *Recollections*, Vol. 1 1786–1816, iii 28, 1910–11 (1865).
17. Henry Lascelles became 2nd Earl of Harewood in 1820, and represented the Tory interest for the County of York. His older brother, Edward 'Beau'

Lascelles (d.1814), was known as the 'Pretender', on account of his resemblance to the Prince of Wales. See D. Hill, 'A Taste for the Arts: Turner and the Patronage of Edward Lascelles of Harewood House', *Turner Studies*, IV ii 1984, V i 1985.
18. Hill, 1984.
19. W.632. Reproduced in colour in J. Gage, *Turner: A Wonderful Range of Mind* (Oxford 1987), pl.240.
20. Hill, 1980, No.80.
21. Hill, 1980, No.79.
22. W.633.
23. Teals, TB CCLXIII 340, 341. Pheasant, woodpecker and picture frame, TB CCLXIII 358, Pheasant and woodpecker, TB CCLXIII 359.
24. Bewick was first published in 1797 (Vol. 1), and 1804 (Vol. 2). The second edition was 1805. We can be sure that the Fawkes family used the 1805 edition since an explanation of technical terms pasted in the first volume of the *Ornithological Collection*, first appeared in that edition. There are 1805 and 1822 editions of Bewick in the Farnley Library today.
25. G. Phelps, *Squire Waterton*, 1976.
26. In a book of caricatures in the Farnley Library.
27. Samuel Howitt (1756–1822). Gentleman devotee of field sports, of Chigwell, Essex. Exhibited 1783–1815. Illustrated sporting and zoological works, including monkeys, cattle, birds and fish. See Iolo Williams, *Early English Watercolours*, 1970 (1952), pp.195–6.
28. Allen, 1976, p.99.
29. Rev. Henry Forster Mills, *Elegiac Stanzas on the death of Walter Fawkes, Esq.*, Bristol 1825, p.5.
30. Allen, 1976, p.30.
31. Gage, 1980, No.323.
32. Copies of the catalogue, referred to in Turner's letter of 27 December 1850 (Gage, 1980, No.318), exist in the National Art Library, Victoria and Albert Museum, and in Bradford Central Library.
33. A point made and much expanded by Allen, 1976, p.100.
34. Gage, 1980, No.329.
35. Quoted W.T. Whitley, *Art in England 1800–1820*, 1928, p.296.
36. Gage, 1980, 112.
37. Gage identifies the Hannah referred to as Hannah Danby, but a Hannah Holmes appears among the staff in Hawksworth Fawkes' book of caricatures in the Farnley Library. It appears very much as if she could have been the cook at Farnley Hall.
38. Gage, 1980, p.307.
39. Gage, 1980, p.315.
40. Gage, 1980, p.323.
41. Edith Mary Fawkes, 'Mr Ruskin at Farnley', in *The Nineteenth Century*, April 1900, pp.617–23.
42. The album in this form was exhibited York 1980, No.78.
43. Sotheby's, 12 July 1984 (58).
44. Edith Mary Fawkes, *op. cit.*, p.622.

Alliss, T. *The Birds of Yorkshire* (York 1844) unpublished manuscript now in the Yorkshire Museum.
Chislett, R. *Yorkshire Birds* (London 1952)
Feltwell, R. *Turkey Farming* (London 1963)
Harris, J. *A Garden Alphabet* (London 1979)
Heinzel, H., R. Fitter and J. Parslow. *The Birds of Britain and Europe, with North Africa and the Middle East* (London 1972)
Kirke-Swann, H. *A Dictionary of English and Folknames of British Birds* (London 1913)
Lewer, S. H. *Wright's Book of Poultry* (London)
Mather, John R. *The Birds of Yorkshire* (London 1986)
Nelson, T. H. *The Birds of Yorkshire*, 2 vols (London 1907)
Vesey-Fitzgerald, B. *British Game* (London 1946)

The Plates

The bird titles given are based on those given by Hawksworth Fawkes in his catalogue of the Farnley Hall Turners, 1850. These are in most cases the oldest and most authentic available. Hawksworth's names for the birds follow Bewick's, and follow the order in which the watercolours would have appeared in the albums of the Farnley Hall *Ornithological Collection*. Because of this, it seems probable that the drawings were still in the albums at the time this list was compiled, with the exceptions of the *Ring Dove*, and *Dead Grouse hanging, killed by the artist*, which were listed on page 3 of the catalogue (the former as 'Stock Dove'), suggesting that these two had already been removed and framed separately. The order in which the birds appear below, therefore, follows their original order in the Farnley Hall *Ornithological Collection*. In the original albums the watercolours were surrounded by an embossed gilt border. Traces of this are still visible in some cases, and this is noted under individual examples.

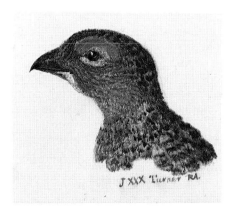

Head of a Grouse
*Watercolour, traces of an embossed border at the left and
right edges, 9.6 × 11.4 cm. From the Farnley Hall*
Ornithological Collection, *Vol. 2. Inscr: (possibly
not by Turner) 'JXXX [MW in monogram] Turner RA'.*

Moorhawk

Head of a Moor Buzzard
*Pencil and watercolour, with traces of a gilt border to the
left and right, 10.8 × 13.5 cm. From the Farnley Hall
Ornithological Collection, Vol. 1.*

Named, misleadingly, by Bewick and The Farnley Album as
a Moor Buzzard, the bird figured by Turner is, in fact, a
Marsh Harrier (*Circus aeruginosus*). The cream-coloured
crown suggests that this is an adult female. Essentially a bird
of fens and reed beds, not moorland, the Marsh Harrier
formerly bred in many areas of Britain, including Yorkshire.
Its natural habitat has declined today because of land
drainage. By the early 1900s, it had been driven into a few
breeding refuges on private estates in East Anglia but,
following protective legislation, the bird has recently been
seen with increasing regularity in many parts of the country.
Since 1963 Marsh Harriers have returned to breed in
Yorkshire on several occasions.

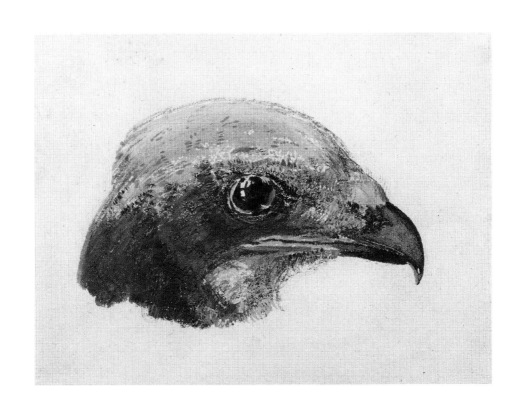

Barn Owl

Head of a White Owl
Watercolour, 26.1 × 19.6 cm. From the Farnley Hall
Ornithological Collection, *Vol. 1.*

Traditionally breeding in barns and other farm buildings,
and living largely on rats and mice, the Barn Owl (*Tyto alba*)
has always been regarded as beneficial to Man. As a rodent-
eater it keeps down farmyard pests. The bird's eerie call,
ghostly, silent flight, and habit of also nesting in and hunting
near churches have added to the folklore and superstition
which surrounds the bird. Known by many local names
including White Owl, Church Owl, Screech Owl, Ullat or
Ullot, its numbers have declined seriously in Britain as a
result of changing agricultural practices, urbanization,
atmospheric pollution and the widespread use of chemicals
on the land.

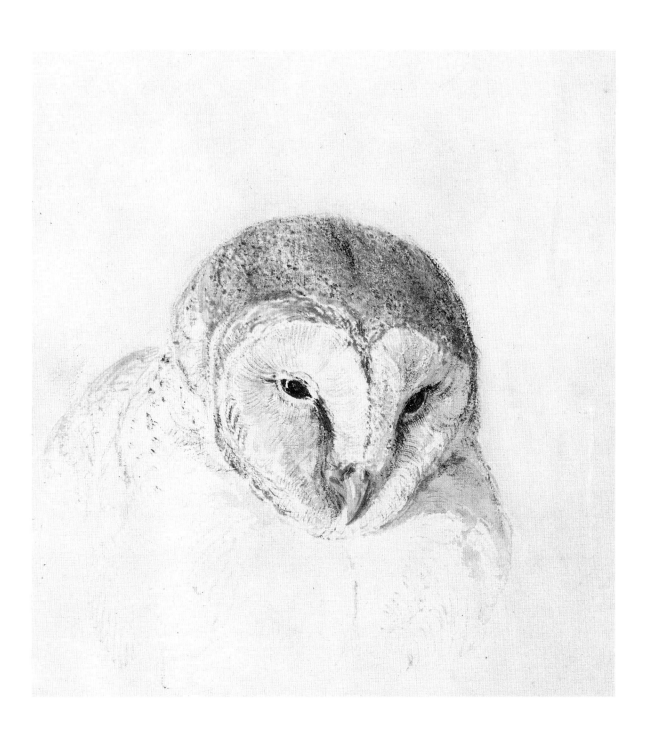

Jay

Dead Jay
*Watercolour, 19.1 × 23.2 cm. From the Farnley Hall
Ornithological Collection, Vol. 1. Inscr: (above
foot) 'IMWT'.*

The Jay (*Garrulus glandarius*) is regarded by gamekeepers as
one of the greatest pests because its diet includes the eggs
and young of many wild and game birds.
Its beautiful plumage, rarely seen in the thick woodland it
resorts to, is also greatly prized by fishermen who use its
blue wing feathers for fly-tying. In the autumn the bird also
feeds on acorns, often storing them underground for later
use, and so acts as an agent in the formation of new
woodland. Because of earlier persecution Jays were almost
exterminated in many parts of Britain, but they are now
common in most parts of the country.

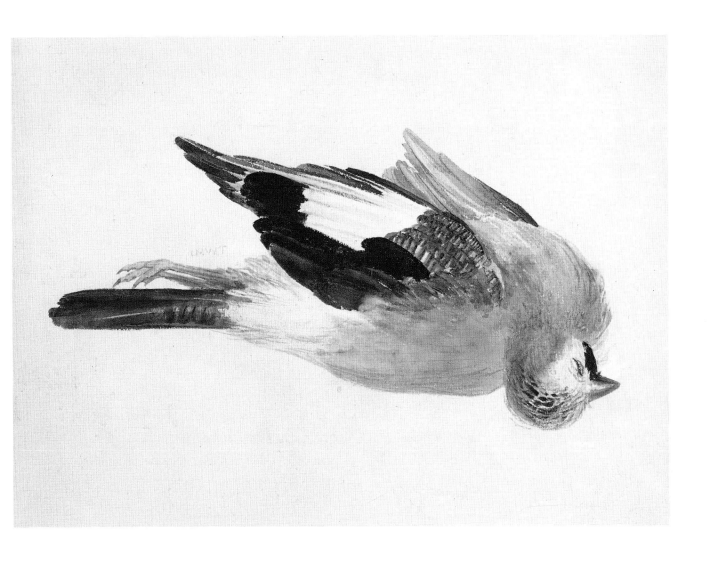

Cuckoo

Head of a Cuckoo
Watercolour, 7.4 × 7.4 cm. From the Farnley Hall
Ornithological Collection, *Vol. 1. Inscr: (perhaps
not by Turner)* 'I MW [*in monogram*] Turner R A'.

The best known and most welcome herald of spring in
Britain is the Cuckoo (*Cuculus canorus*). It arrives here in April
and departs again in August, and is found commonly
throughout the country.
The female Cuckoo normally lays about a dozen eggs in a
season and usually in the nests of the same host species, most
often the Dunnock or the Meadow Pipit. Cuckoos are
beneficial to agriculture, consuming hairy caterpillars
untouched by other birds.
Young Cuckoos, of which Turner's painting is an example,
migrate to their winter quarters in Africa some weeks after
their natural parents and so make the long journey unaided.

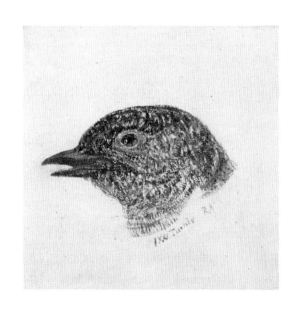

Green Woodpecker

Head of a Green Woodpecker
Watercolour, 24.3 × 18.8 cm. From the Farnley Hall
Ornithological Collection, *Vol. 1.*

The brightly plumaged Green Woodpecker (*Picus viridis*) is
the largest British woodpecker, occurring throughout
England and Wales. Turner's painting depicts a male bird
whose colouring is darker around the face than the female. It
has colonized southern and central Scotland only since the
early nineteenth century and, like the other British species,
does not breed in Ireland.
As much of the old, broad-leaved woodland disappeared, it
found the mature trees of private parkland very much to its
liking, and is now a characteristic bird of such areas.
Conspicuous in spring by its loud song, or 'yaffle', which
was thought to herald rain, its many common names include
Rainbird, Popinjay, Woodawl and Hewhole.

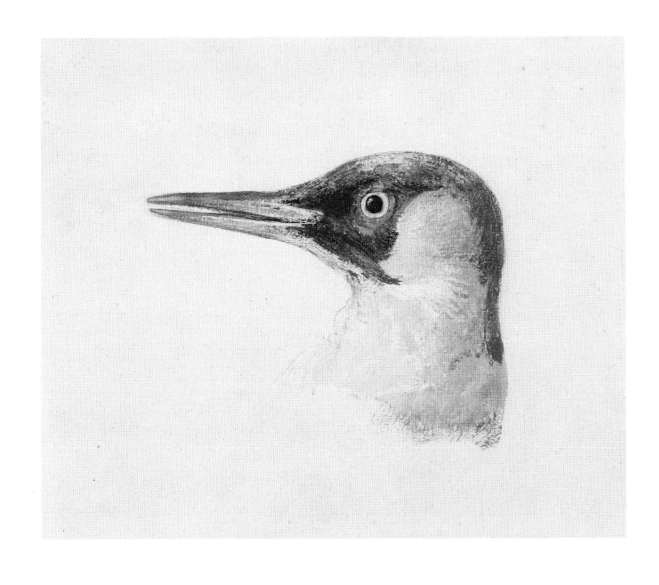

Goldfinch

Goldfinch
Pencil, watercolour and scratching out, 17.5 × 14.5 cm.
From the Farnley Hall Ornithological Collection,
Vol. 1.

The Goldfinch (*Carduelis carduelis*) depicted here would have
been a cage bird. The progressive eradication from farmland
of seed bearing weeds on which it feeds had caused the
Goldfinch to virtually disappear from much of Britain prior
to the Protection of Birds Act in 1954. But today there are
few places in Yorkshire where flocks of Goldfinches, or
'charms', cannot be seen. This is also the case throughout
most of the country. Known locally as Thistle Finch, Goldie
or Gowdspink. The author recalls seeing his first Goldfinches
in 1958, feeding on Burdock seeds near Harewood
Park in Wharfedale, only a stone's throw from Farnley.

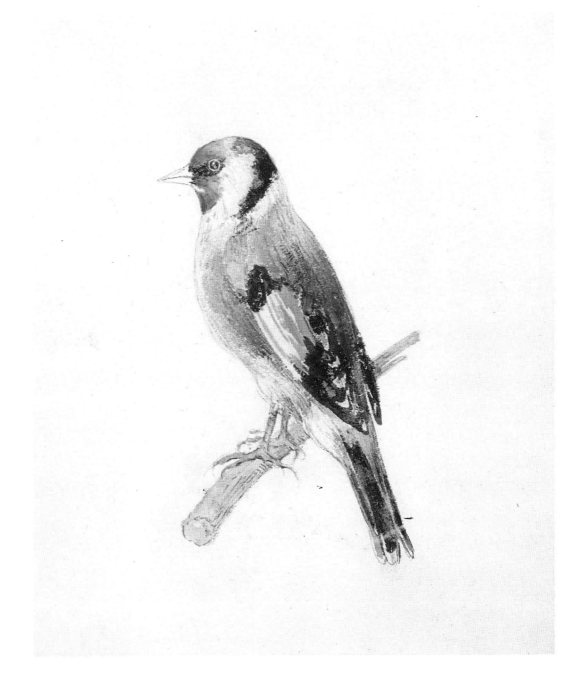

Robin

Robin Redbreast
Watercolour, traces of an embossed border on the left and
right edges, gilt at the left, 14 × 17.7 cm. From the
Farnley Hall Ornithological Collection, *Vol. 2.*
Inscr: (lower left) '*JMW Turner*'.

The welcome autumn song and confiding habits of the
Robin (*Erithacus rubecula*) have endeared the bird to Man for
many centuries. Its supposed association with The
Crucifixion and the superstitious belief that it covers
unburied bodies with leaves and moss, giving rise to the
legend of 'The Babes in the Wood', have also endowed it
with special respect. As the poet William Blake wrote . . .
'A Robin Redbreast in a cage, puts all Heaven (and Earth) in
a rage'.
Originally a forest bird, the Robin is common throughout
Britain, and many more from the Continent join our native
birds to spend the winter here. This Robin was probably a
wild bird and drawn from life.

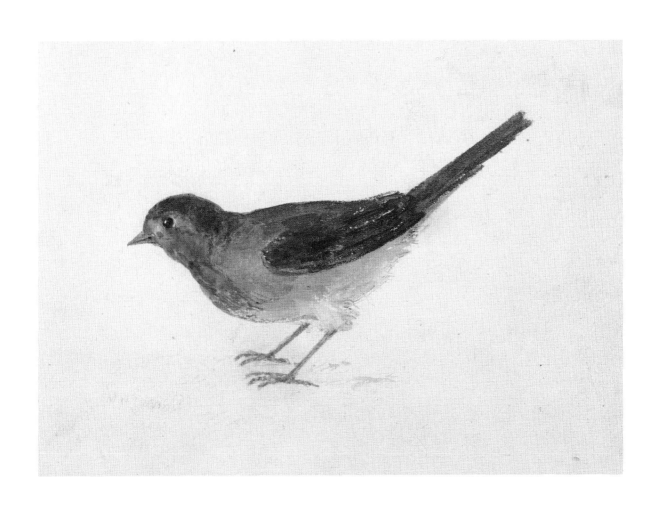

Woodpigeon

Dead Ring Dove
Watercolour, 21 × 28.5 cm. From the Farnley Hall
Ornithological Collection, *Vol. 2.*

Commonly known as the Ring Dove, Stockie, Cooshout or
Cushie and Clatter Dove, the Woodpigeon (*Columba
palumbus*) is a bird found abundantly in British woods and
farmland. Its numbers are augmented in winter by the
arrival of migrants from the Continent.
Good to eat and popular for shooting, they were an
important and cheap item of fare for many country folk.
Woodpigeons are also a serious pest to farmers as is
suggested in one old North Country saying:

Sow four beans in a row.
One to rot, one to grow,
One for the Pigeon, and one for the Crow.

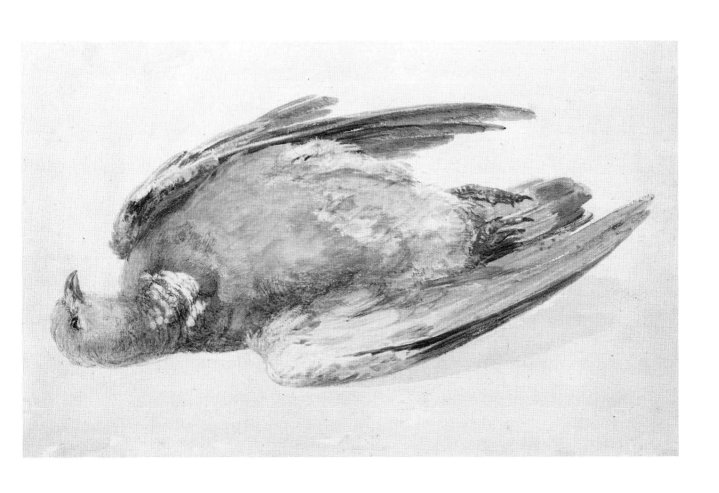

Gamecock

Head of a Game Cock
*Pencil and watercolour, 18.4 × 22.2 cm. From the
Farnley Hall Ornithological Collection, Vol. 2.
Inscr: (lower right) 'I MW [in monogram] Turner'.*

The natural territorial aggressiveness of the wild male Red
Jungle Fowl of southern Asia (*Gallus gallus*), has been
exploited for public spectacle and wager for thousands of
year. Cockfighting has been documented in India at least as
early as 1000 B.C. It has been present in this country since
before Roman times. It developed into an organized national
pastime during the reign of Henry II. Subsequently it
flourished for at least seven hundred years. In 1822 £6,000
was won on a single fight, and in one English town more
than a thousand cocks were killed in a single season. The
head of the Gamecock painted by Turner was not a fighting
bird as its plumage and wattle have not been trimmed.
English Game Fowl are now kept for show or for the table.

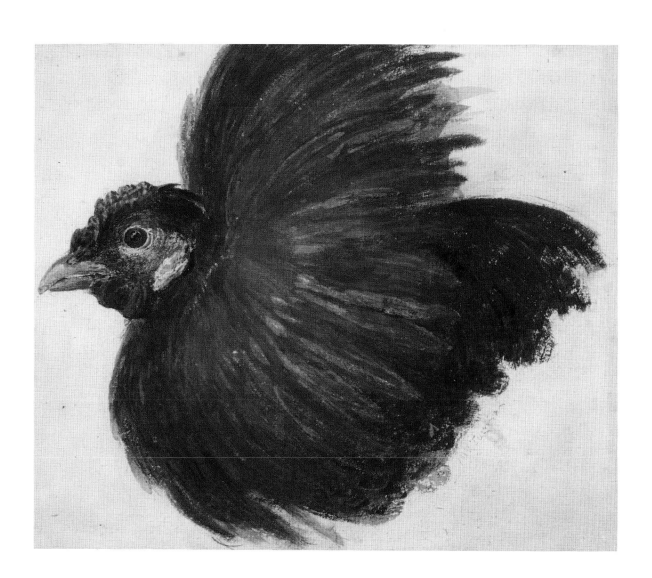

Pheasant

Head of a Hen Pheasant (above)
*Watercolour, traces of an embossed border at left and
right edges, 11.6 × 10 cm. From the Farnley Hall*
Ornithological Collection, *Vol. 2. Inscr: (possibly
not by Turner)* 'JXXX [MW in monogram] Turner RA'.

Head of a Cock Pheasant (below)
*Watercolour and scratching out, 11.3 × 11.2 cm. VM
'WHATMAN' along left edge, partly cut off. From
the Farnley Hall* Ornithological Collection, *Vol. 2.
Inscr: (possibly not by Turner)* 'JMW [in monogram]
Turner RA'.

The Pheasant was probably introduced into Britain by the
Romans towards the end of their occupation. The so-called
'Old English' race of the Pheasant (*Phasianus colchicus*), with a
totally dark head and neck, came from the Caucasus
mountains and south west Asia. Later introductions of the
form with a white neck ring were from China and the Far
East. In a semi-domesticated state Pheasants now occur
throughout most of Britain. Not being a native bird, the
Pheasant would not survive in the wild as it would be the
prey of foxes, stoats, and weasels.
Formerly kept for show in ornamental houses, or
pheasantries, the large-scale rearing of pheasants for sport
dates back in this country only to the 1850s.

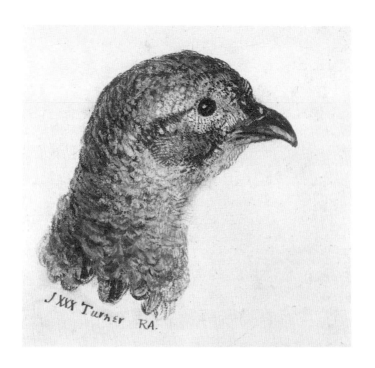

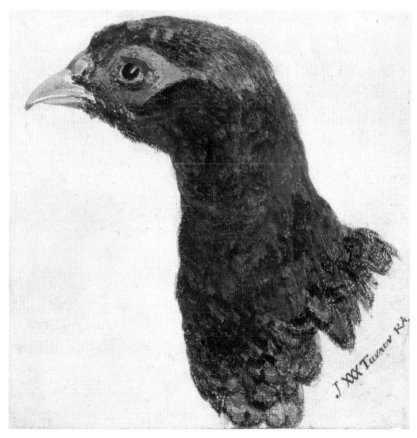

Turkey

Head of a Turkey Cock
*Watercolour, 12.2 × 12.5 cm. From the Farnley Hall
Ornithological Collection, Vol. 2. Inscr: (possibly
not by Turner) 'JMW [in monogram] Turner R A'.*

Erroneously believed to have originated in the old Turkish
Empire, and thus misleadingly named, the wild Turkey
(*Meleagris gallopavo*) is a woodland bird of central and
southern North America.

Turkeys were first introduced into Britain, in East
Yorkshire, from Mexico via Spain, for shooting as game
birds, probably in the early part of the sixteenth century. By
the 1600s it was firmly established as an English traditional
Christmas dish. The Turkey painted by Turner would have
been bred for its eggs or for the table. In America the
Indians believed that a good crop of maize could be assured
by sprinkling the blood of a beheaded Turkey in a corner of
the newly planted field.

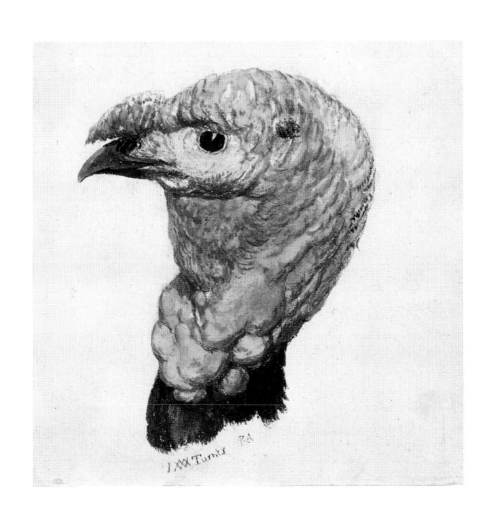

Peacock

Head of a Peacock
*Watercolour and scratching-out, 32.5 × 23.8 cm. From
the Farnley Hall Ornithological Collection, Vol. 2.
Inscr: (scratched through point on neck) 'I MW
Turner'. A preliminary pencil sketch of a peacock's head
on the reverse.*

This Peacock was probably from the grounds of Farnley
Hall. No self-respecting owner of an eighteenth or early
nineteenth century garden would have neglected to provide
a few eye catching Peacocks (*Pavus cristatus*) to embellish the
architecture and ennoble the landscape. A forest bird of
China, India and adjacent islands, the date of its introduction
into Britain is not precisely known. However, it is recorded
that in 1254 Henry III offered a Peacock as a prize for
running in races, and the bird also featured on the menu at
the wedding feast of Henry VI in 1445.
This drawing was exhibited separately at Fawkes' exhibition
at his London House, 45 Grosvenor Place, in 1819. This
may suggest that it was then new, and had not yet taken its
place in the *Ornithological Collection*. The Peacock was
sometimes used by Turner as an emblem of himself as, for
example, in the frontispiece to the *Liber Studiorum,* or the oil
painting so-called *The Thames at Weybridge*, now at Petworth
House, Sussex.

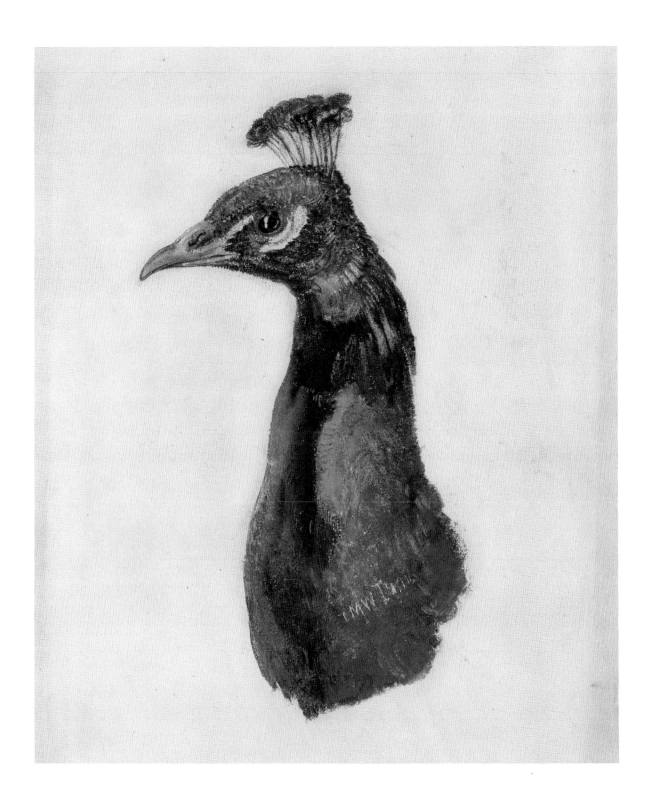

Guinea Fowl

Head of a Guinea Fowl
Watercolour, 9.7 × 10.2 cm. Not listed in the
Ornithological Collection, *but probably included with
other domestic birds in Vol. 2. Inscr: 'I MW [in
monogram] Turner RA'.*

The Helmeted Guinea Fowl (*Numida meleagris*) originated
from North Africa where it was well known to the Romans,
who domesticated it for culinary purposes. It was probably
introduced into Britain during the Roman occupation.
In North Africa the Guinea Fowl is much prized as a game
bird, and in the wild is now confined to parts of Morocco.
Here it is now rather uncommonly reared for its excellent
flesh. Its chequered plumage also once made it a decorative
species for show.

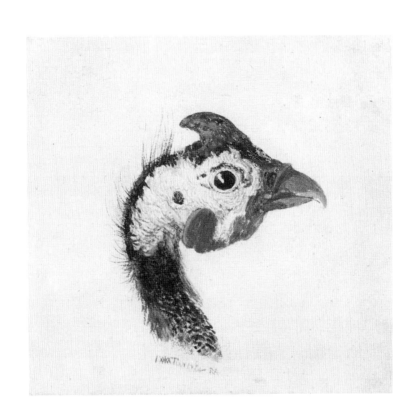

Red Grouse

Dead Grouse hanging, killed by the artist
Pencil and watercolour, 26.2 × 20.6 cm. From the
Farnley Hall Ornithological Collection, Vol. 2.
Inscr: (below wing, lower right) 'I MW [in monogram]
Turner RAPP'. Just above this inscription there are
traces of another inscription having been scratched off.

The bird depicted here was probably brought off the moor
from a shooting trip.
Long thought to be a uniquely British bird, the Red Grouse
is now considered to be merely a member of the Willow
Grouse (*Lagopus lagopus*) family. Also known as the
Moorfowl, it is a bird of the peaty heather moors, being
indigenous throughout much of Ireland, Wales, Scotland,
and England north of the Peak District.
The organized management of moors for grouse shooting,
which developed into one of the most important events in
the English sporting and social calendars, began only
relatively recently. This was, in fact, prompted by the advent
of the railways and the introduction of the breech loading
gun in 1853.

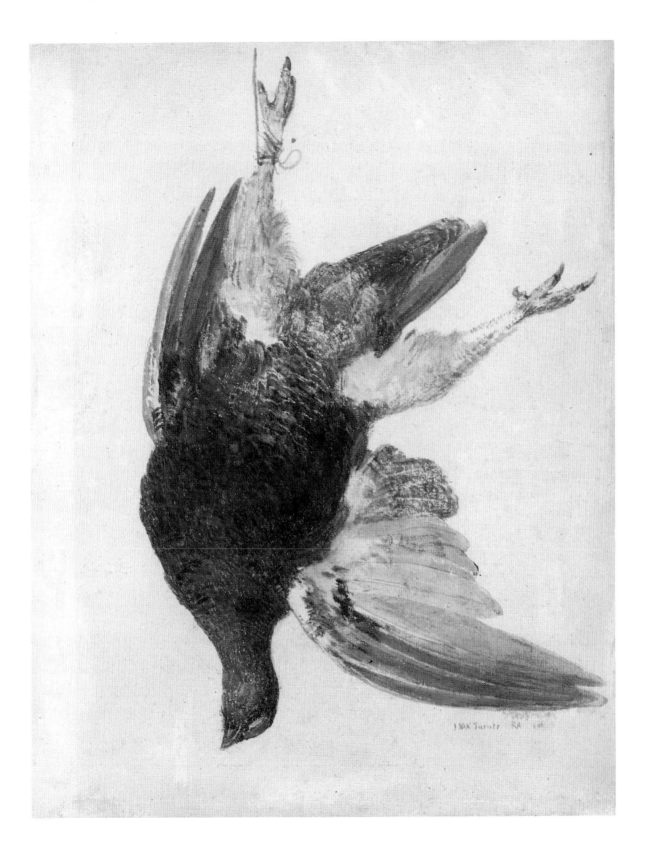

Partridge

Head of a Partridge
Pencil and watercolour traces of an embossed border at the left edge, 9.2 × 10.1 cm. WM 'J WHAT[MAN]' along lower edge, partly cut off. From the Farnley Hall Ornithological Collection, Vol. 2. Inscr: (possibly not by Turner) 'JXXX [MW in monogram] Turner RA'.

The bird figured in Turner's painting is the native British Common or Grey Partridge (*Perdix perdix*). Typically a bird of farmland, the Grey Partridge has recently suffered greatly from changing agricultural practices, especially hedgerow and scrub clearance, intensive monoculture and the use of herbicides and pesticides. In 1393 in Yorkshire the price of a Partridge for the table was set at 2d, and on 23 September 1884 Earl de Grey, single handedly, shot 303 birds during the course of the day.

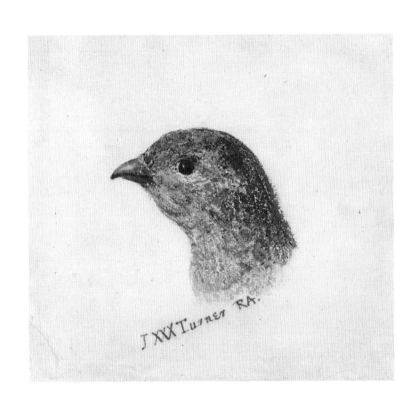

J.XX.Turner R.A.

Woodcock

Head of a Woodcock
*Watercolour traces of an embossed border at the left edge,
14.1 × 16.9 cm. From the Farnley Hall*
Ornithological Collection, *Vol. 3.*

Known by the Anglo-Saxons as Wudcoc, and in Old English
as Wodcock, the Woodcock (*Scolopax rusticola*) is a common
British woodland bird. Additional birds from the Continent
also winter here. Regarded as excellent eating, four hundred
Woodcocks were once served at the banquet to celebrate the
enthroning of George Newell as Archbishop of York in
1466. At dusk the bird's slow, bat-like display flight, or
'roding', along wood edges and rides is a familiar country
sight in spring. It is also reputed to fly its young out of
danger, carrying them between its thighs.

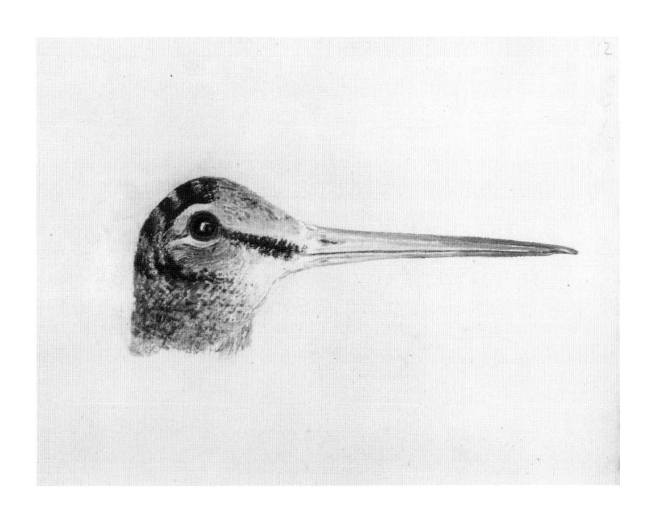

Kingfisher

Dead Kingfisher
Watercolour, 17.7 × 16.4 cm. From the Farnley Hall
Ornithological Collection, *Vol. 3. Inscr: (lower*
right) 'I MW *[in monogram]* Turner RA'.

The beautiful Kingfisher (*Alcedo atthis*) has suffered greatly as
a species. It is very susceptible to hard winters and water
pollution, and has been much persecuted in the past by
taxidermists, milliners and fishermen. Wharfedale, near
Farnley, has always been a reliable place to see Kingfishers,
and they are probably as numerous there and elsewhere in
Britain today as they have ever been.
This drawing is the only one for which a preliminary pencil
sketch survives in the Turner Bequest (TB CXXXIV 1).
The Yorkshire drawings in this sketchbook can be dated to
1816, thus providing a basis for dating the finished
watercolour, and perhaps suggesting a date for Turner's
other contributions to the *Ornithological Collection*.

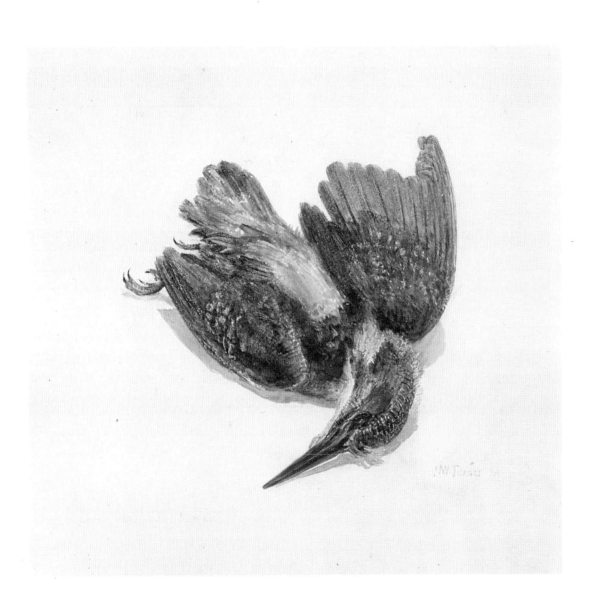

Heron

Head of a Heron
Pencil and watercolour, 24.9 × 28.9 cm. From the
Farnley Hall Ornithological Collection, *Vol. 3.*

As far back as the thirteenth century the Grey Heron (*Ardea cinerea*), or Hern, was maintained in England as a source of quarry for hawking. The young birds also provided valuable fresh meat in the early spring. The subsequent break up of the large, private estates resulted in the abandoning of many ancient heronries, and a survey in Yorkshire in 1971 revealed the existence of only nine remaining colonies in the county, comprising about two hundred pairs of birds. More recent threats to the bird are posed by fishermen and water bailiffs, and residues from agricultural chemicals. Herons are dependent on clear, fresh water for survival.

It is perhaps significant that Turner's drawings were all contained in the first three volumes of the *Ornithological Collection*. It is possible that volumes four and five were not yet begun when Turner made his drawings, or that he worked through the volumes in order, and only progressed as far as Volume Three.

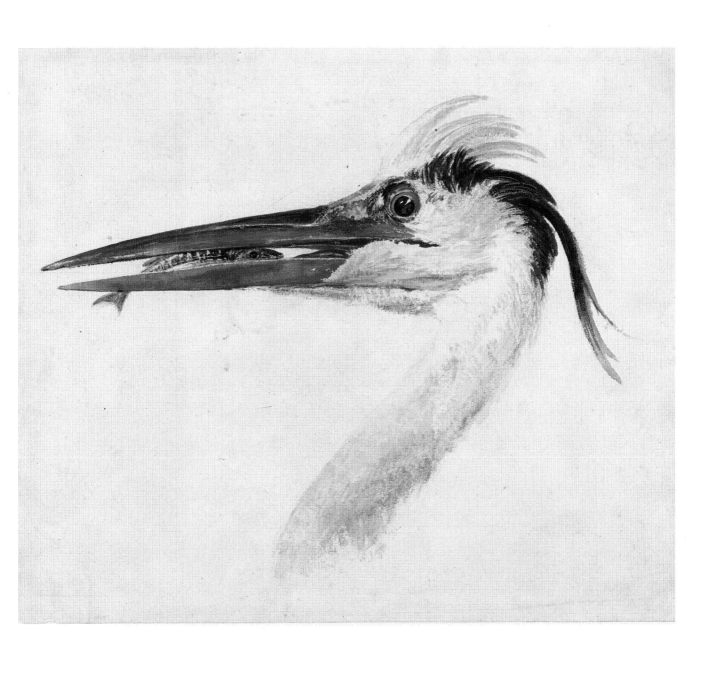

Index